T0009542

A LOOM OF
ONE'S OWN

HarperCollins*Publishers*
1 London Bridge Street
London SE1 9GF

www.harpercollins.co.uk

HarperCollins*Publishers*
Macken House, 39/40 Mayor Street Upper
Dublin 1, D01 C9W8, Ireland

First published by HarperCollins*Publishers* 2022

10 9 8 7 6 5 4 3 2

© HarperCollins*Publishers* 2022

Anna Mrowiec asserts the moral right to be
identified as the author of this work.

A catalogue record of this book is
available from the British Library.

ISBN 978-0-00-852924-6

Printed and bound in Malaysia

This book is produced from independently certified FSC™ paper
to ensure responsible forest management.

For more information visit: www.harpercollins.co.uk/green

VIRGINIA WOOL

A LOOM OF ONE'S OWN

CRAFTS FOR BOOK LOVERS

HarperCollins*Publishers*

CONTENTS

DEAR READER

The decision to purchase this book may have been a difficult one for you. To have done so, you must clearly like books, and so the idea of cutting into them, removing their pages or gluing them together so they can no longer be read… it may not be an easy thing for a true book lover to stomach.

But here I must stress that I could never promote the needless or senseless destruction of our most precious resource. The idea of the crafts described within these pages is not to destroy but to create. To take old, damaged or underloved books and give them a new reason to be – a new purpose. To celebrate a love of reading, to exalt beautiful covers or even the words that once were read in new and wonderful ways. To make the unwanted, wanted. The pre-loved, reloved.

And let us not forget, the beauty of a book is not only in the words it contains (if that were true, sales of electronic books would be much higher than they are). There is a certain magic in holding a book in your hands – the smell and weight of it, the promise of the world contained within it, the history of where it has been and who has read it before, the beautiful cover design that so often is indicative of what you'll find inside (ignore those who say a book cannot be judged by its

cover – book publishers and designers take a lot of care to create an appropriate jacket for each title). A book as an object is a wonderful thing, often with a rich and varied past, so there should be no shame in celebrating your tomes for the visual and tangible appeal they hold.

But certainly, do not go out and buy pristine new copies of your favourite books for these crafts; and be sure you're not slicing into any priceless first editions either (admittedly, the chance of happening upon one is low, but not impossible). Instead, here are some places you may wish to plunder to obtain the most important resource for these craft projects: beautiful books.

AT HOME

A lot of us have books on our shelves gathering dust, many of which aren't suitable for resale as their pages are starting to come loose or they have been drawn on or otherwise defaced. Start by rummaging through your own shelves for any gems, or those of relatives and friends who are looking to Marie Kondo their homes.

LOCALLY

A lot of great books can be found at car-boot sales, in charity shops or at recycling centres – you just need to keep an eye out. You could also try asking at your local library, as they may have a sale planned or titles that they throw out periodically (many old reference books become outdated, particularly dictionaries or textbooks).

THE INTERNET

You may be able to get some books free, or at least very cheaply, via freecycle websites, Facebook marketplace or resale sites like eBay. Site names will vary depending on the country you're in, but a quick google for vintage books should bring up relevant pages.

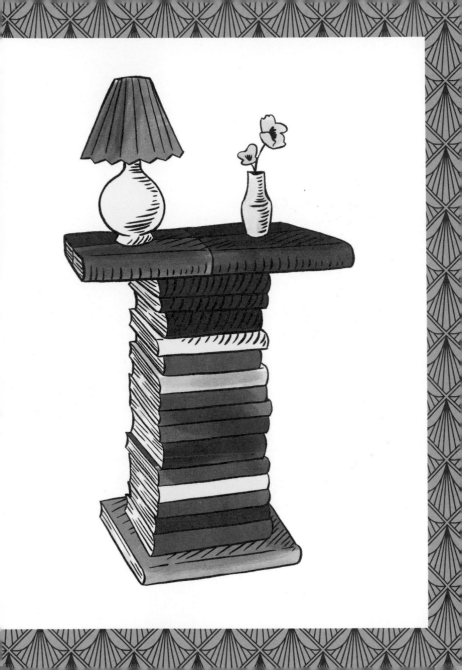

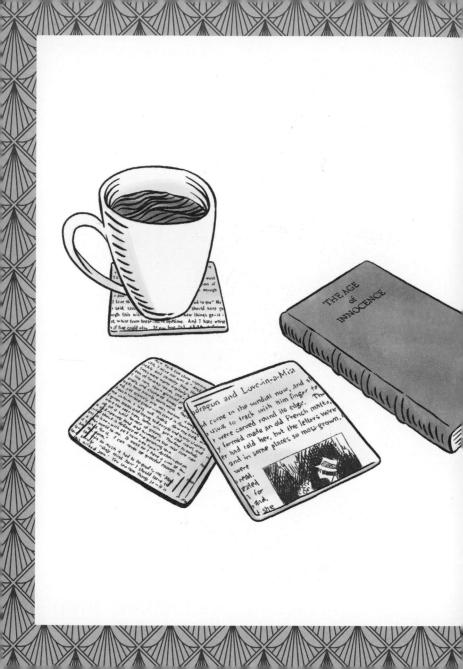

You can also easily find scans of books online (try searching 'antique book pages' on Google), so if a craft calls for 'book pages' you could always print off the ones you need. Another option is to scan books you own and print those off to the requisite size.

With volumes in hand and some basic craft supplies, you should be ready to start bringing your love of classic books into every part of your home, from your light switches and bedside table (see pages 12 and 60) to your doormat and your shelves (see pages 88 and 124). No visitor to your house will be in any doubt about your romance with literature, as you display it loud and proud. But you can also take your passion for reading to the seaside (see page 32) or on a picnic (see page 120); and there are even ideas in here for the literary-themed wedding of your dreams.

Whether this is your first time transforming a book into something new and wonderful or you're a seasoned book-crafter looking for more inspiration, you will find many ideas in these pages to spark your imagination. There are crafts for every skill level, and many that call for only very basic tools and resources. And all you need besides that is a little time, love and a sense of wonder.

So fill your rooms with books, wherever they may fit. For as the wise Cicero once said, 'A room without books is like a body without a soul'.

Yours,

Virgina Wool

THE LION, THE SWITCH AND THE WARDROBE

This nifty little decoupage project will add a touch of magic to any room – so much so that you'll swear you've taken a dive through the back of your wardrobe. Take a beautiful page from a book of your choice (although, of course, we recommend C. S. Lewis), get yourself a switch plate and you're good to go! (Turkish delights while you work are optional.)

YOU WILL NEED:

- Book page (loose)
- Switch plate (for a single light switch), unscrewed from your wall, plus screws
- Mod Podge
- Glue brush
- Scissors (or craft knife)
- Screwdriver

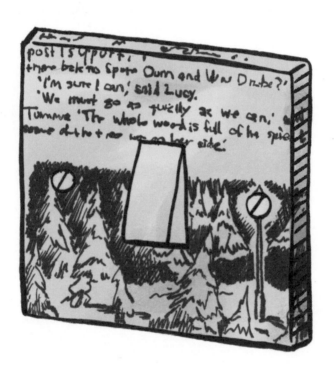

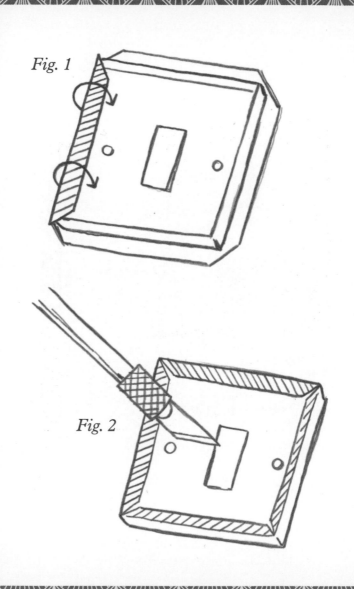

Fig. 1

Fig. 2

TO MAKE THE SWITCH:

1. Cut your book page so that it is at least 1cm bigger on all sides than the switch plate being used.
2. Apply Mod Podge to the back of the page, then place the switch plate (front-side down) on top of it.
3. Cut the corners of the paper away, then fold in the sides and glue them to the back of the switch plate.
4. Trim the points of the top and bottom flaps on the diagonal, then fold them in and glue them down, too (see Fig. 1).
5. Use scissors (or a craft knife, if you have one), with the switch plate still facing down, to cut out a hole in the paper by running the craft knife along each of the edges of the switch-plate hole (see Fig. 2).
6. Poke holes through for the screws, and then screw the switch plate over the light switch.

Mr Tumnus should show up in no time!

FIVE GO TO SMUGGLER'S CAKE TOPPER

Whether or not you're celebrating discovering treasure at the old mill, these gorgeous cake toppers are sure to enliven any picnic. Just pack them into your wicker basket with lashings of ginger beer, ham rolls and some cupcakes to stick them into, of course, and you've got yourself a party – even better if Dick smuggles in something stronger to drink.

YOU WILL NEED:

- Scissors
- Coloured card/scrapbooking paper
- Book pages
- Glue
- Toothpicks

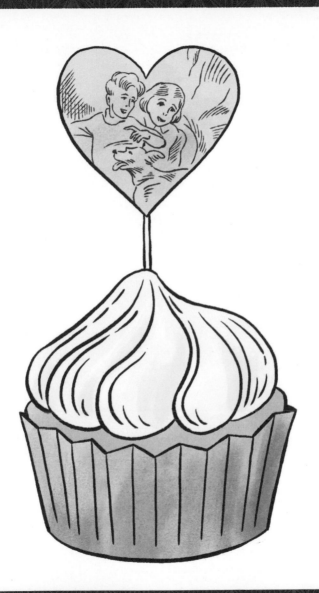

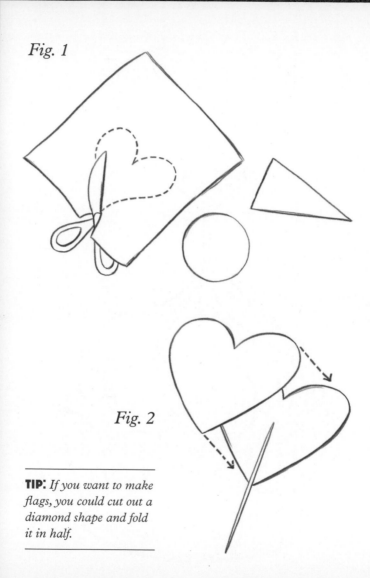

Fig. 1

Fig. 2

TIP: *If you want to make flags, you could cut out a diamond shape and fold it in half.*

TO MAKE THE CAKE TOPPER:

1. Cut out whatever shapes you fancy from your card or scrapbooking paper – you could go for simple circles, jaunty flags or even hearts, if the occasion is romantic (see Fig. 1).

2. Using these shapes as stencils, cut the same shapes from your book pages.

3. Glue the insides of two shapes you've cut out, sandwich a toothpick between them and press them together, ensuring that the edges are perfectly lined up (see Fig. 2).

Hey presto! Aunt Fanny will be pleased!

LOVE IN THE SPINE OF CHOLERA

What could be more romantic than turning your favourite book into a heartfelt work of art for the one you love? Surely a more welcome gift than simply pining away in silence for five decades! This gorgeous craft is perfect for weddings, anniversary parties, Valentine's day – or any day you're feeling amorous (whether or not you're living through a cholera epidemic).

YOU WILL NEED:

- Hardback book
- Ruler
- Pencil

TO MAKE THE BOOK ARTWORK:

1. You need 42 separate pages for this craft, so find those pages in the middle of your book (see Fig. 1).

2. Place a ruler down the right-hand side of the first of these pages. Use a pencil to score a little mark at 8.3cm and 9.1cm (see Fig. 2).

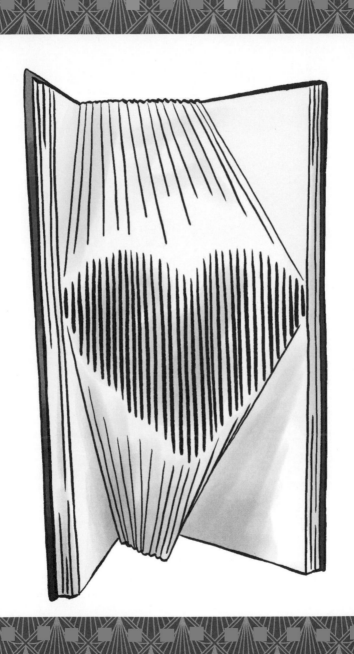

Fig. 1

42 pages

Fig. 2

3. Continue with the remaining pages, marking each new page on the right, as follows:

- Page 2: 7.5cm; 9.5cm
- Page 3: 7cm; 10cm
- Page 4: 6.7cm; 10.3cm
- Page 5: 6.5cm; 10.7cm
- Page 6: 6.3cm; 11cm
- Page 7: 6.2cm; 11.3cm
- Page 8: 6.1cm; 11.7cm
- Page 9: 6cm; 11.9cm
- Page 10: 6cm; 12.2cm
- Page 11: 6cm; 12.5cm
- Page 12: 6cm; 12.7cm
- Page 13: 6cm; 12.9cm
- Page 14: 6.1cm; 13.2cm
- Page 15: 6.1cm; 13.4cm
- Page 16: 6.1cm; 13.6cm
- Page 17: 6.3cm; 13.8cm
- Page 18: 6.5 cm; 14.1cm
- Page 19: 6.7cm; 14.3cm
- Page 20: 6.9cm; 14.5cm
- Page 21: 7.1cm; 14.6cm
- Page 22: 7.1cm; 14.6cm
- Page 23: 6.9cm; 14.5cm
- Page 24: 6.7cm; 14.3cm
- Page 25: 6.5cm; 14.1cm
- Page 26: 6.3cm; 13.8cm
- Page 27: 6.1cm; 13.6cm
- Page 28: 6.1cm; 13.4cm
- Page 29: 6.1cm; 13.2cm
- Page 30: 6cm; 12.9cm
- Page 31: 6cm; 12.7cm
- Page 32: 6cm; 12.5cm
- Page 33: 6cm; 12.2cm
- Page 34: 6cm; 11.9cm
- Page 35: 6.1cm; 11.7cm
- Page 36: 6.2cm; 11.3cm
- Page 37: 6.3cm; 11cm
- Page 38: 6.5cm; 10.7cm
- Page 39: 6.7cm; 10.3cm
- Page 40: 7cm; 10cm
- Page 41: 7.5cm; 9.5cm
- Page 42: 8.3cm; 9.1cm

4. Once you have marked all the pages, you can begin folding. Starting back at page 1, fold the two corners towards yourself, as far as the pencil marks (see Fig. 2). Repeat for all the remaining pages.

How lovely! And even if you don't have a loved one to give it to, you can sure as hell love this book – and know that it loves you right back.

TRISTRAM SHANDELIER

What better way to prove what a bookworm you are than with a three-book chandelier hanging somewhere prominent in your home? Every visitor will be sure to remark upon this stunning addition – and if they don't, you can, of course, point it out to them!

YOU WILL NEED:

- Craft knife
- 3 hardback books of the same size (23 x 18cm each)
- Leather punch
- Hammer
- Adhesive linen bookbinding tape
- Awl
- 30cm wooden embroidery hoop
- 3 x 9.5mm screws
- Screwdriver
- Spring clamps
- 4 x 50cm lengths of craft wire
- Light-cord set
- Light bulb

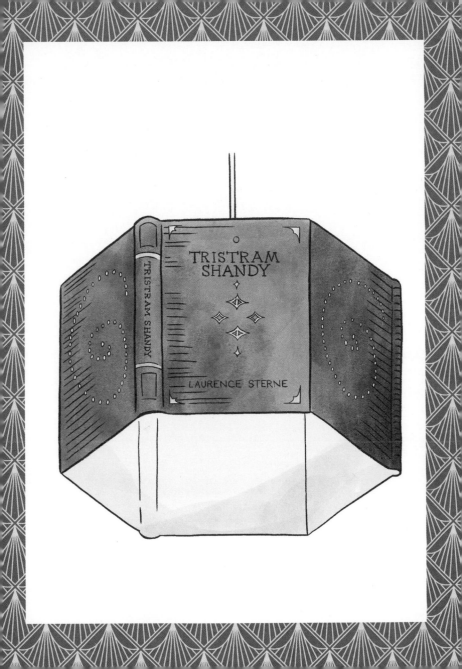

Fig. 1

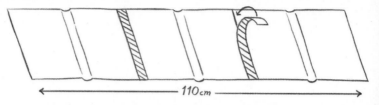

110cm

Fig. 2

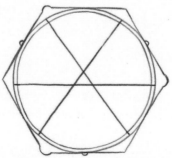

TIP: *When you're punching your holes, it's best to do this against a surface such as an old cutting board.*

Fig. 3

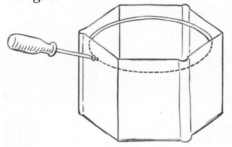

TO MAKE THE CHANDELIER:

1. Use a craft knife to carefully remove the covers from your hardback books.

2. Punch at least fifty holes into the back covers of your books using the leather punch and hammer, so that plenty of light comes through (see Tip). You can punch the holes at random, or make any pattern you prefer.

3. To stick the covers together, place them all down in a line horizontally, with the insides facing you, and lay the bookbinding tape along the connecting edges (see Fig. 1). You need the total length of your joined books to be 110cm – if it's short, add a strip of something thick, like mount board to lengthen. To stick the outside edges of the books together to make a circle, stand them upright and connect using the linen tape.

4. From the outside, make a hole in the front cover of each book using an awl, placing it 2.5cm from the top and centred between each side.

5. Place the embroidery hoop inside the chandelier then, one by one, insert the screws into the holes and screw the hoop into place. If you have clamps, it will make this process easier (see Fig. 2).

6. Attach three of the lengths of craft wire to the hoop at equidistant points. Then attach each wire to the opposite side of the hoop, ensuring they are pulled taut. This will create a small triangle in the middle (see Fig. 3).

7. Thread the light-cord plug through the triangle, until the socket rests inside it. Take the remaining length of craft wire and wrap it around the cord and the wires around the triangle, to keep the socket in place. There isn't an exact science to this, but weave over, under and around all the wires, until the socket feels secure.

Et voila! Just add your bulb, attach the chandelier to the ceiling of your favourite room and you'll have plenty of light to read about Tristram's life and opinions late into the night.

NEVER LET ORIGAMI GO

Drinking never felt so dystopian . . . Of course, that may be because drinking from something made of paper is unlikely to end well, but these sweet little cups are great for holding your earrings, serving nuts in or simply as decorative pots. They look particularly good made with book papers, sheet music or vintage-style scrapbook paper. But as book paper is often quite thin, it may be best to scan a page and print it off on A4.

YOU WILL NEED:

- Your paper of choice (you could start with A4), cut into a square

big liss

ten arcella la ed back;

eff . little help from grand

country ntry folks call benches

little s, filled in a few plac

om... ey should not wash. At lea o, he

M or has followed the pattern set

eild of our orchards — also of the fact that th

brand that always to fey the top of the ma

obody can quit l Pity, because no

just such an how the trellis was a ods in a big

in double rank, one in

Along the curving back well,

Then tips were mud boy's edu

growing scarlet

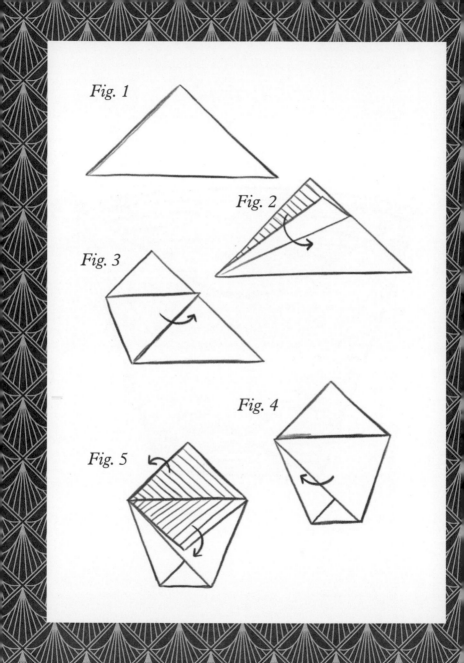

Fig. 1

Fig. 2

Fig. 3

Fig. 4

Fig. 5

TO MAKE THE CUPS:

1. Fold the paper in half diagonally, by taking the bottom corner to the top corner (see Fig. 1).

2. Fold the left side of the triangle along the bottom edge, then fold back. This will leave a crease line (see Fig. 2).

3. Fold the left corner up, so that the point meets the end of the crease line you just made on the right (see Fig. 3).

4. Fold the right corner to the left corner (see Fig. 4).

5. You now have two flaps on top; fold these down, away from each other (see Fig. 5).

6. Open the cup up by separating the two top edges (see Fig. 6).

These are so cute – you'll never want to let them go.

I CAPTURE THE SANDCASTLE

*A very simple craft that's perfect for making with kids –
particularly those with a strong sense of ownership over
their sandcastle creations (or a conquering eye on those
made by others).*

YOU WILL NEED:

- Illustrated book pages
- Scissors
- Coffee stirrers/clean ice-lolly sticks
- Glue

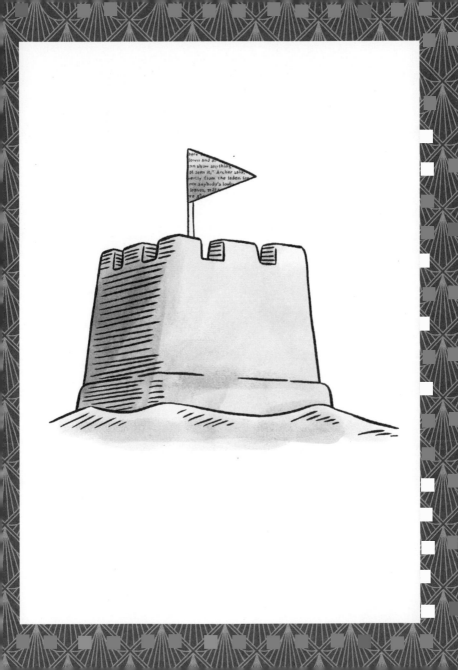

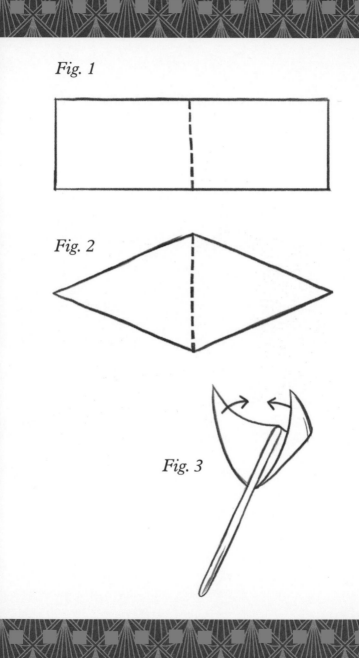

Fig. 1

Fig. 2

Fig. 3

TO MAKE THE FLAG:

1. Cut your pages to the desired shape and size – either a rectangle if you want a square flag (see Fig. 1) or a diamond if you want a triangular one (see Fig. 2).

2. Fold the paper over, ensuring the sides line up.

3. Place a stirrer/stick in the seam and glue it all together (see Fig. 3).

Even if your kids won't allow you to simply lie on the beach and read, you can still add a literary touch to the proceedings.

TIP: *If you are using black and white narrative pages, why not draw or paint something over them in watercolour paint, so the words still show through?*

A TALE OF FIVE CITIES

Whether you live in Bermuda or Berkhamsted, we all like to escape into the fictional worlds of our favourite novels. From the Emerald City to Neverland, Hogsmeade to Narnia, there are endless cities and towns to discover – even if some, like Dickens' London, are full of workhouses and pickpocketing orphans and are kind of depressing.

Why not celebrate your very favourite mythical worlds with this whimsical signpost – perfect to showcase at a wedding or just to pop up outside your house to confuse your non-reader neighbours.

YOU WILL NEED:

- Thin planks of wood – palette wood might work well
- Saw – tenon or wood saw
- Exterior wood paint
- Fine paintbrush
- Hammer
- Wooden pole with stake
- Galvanised nails (long enough to go through your planks with at least 2.5cm out the other side)

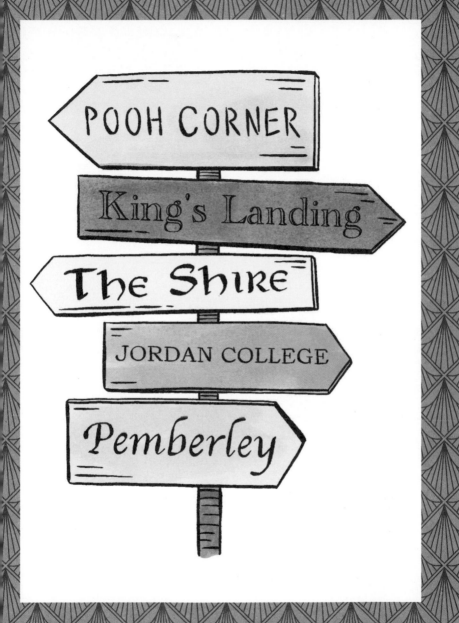

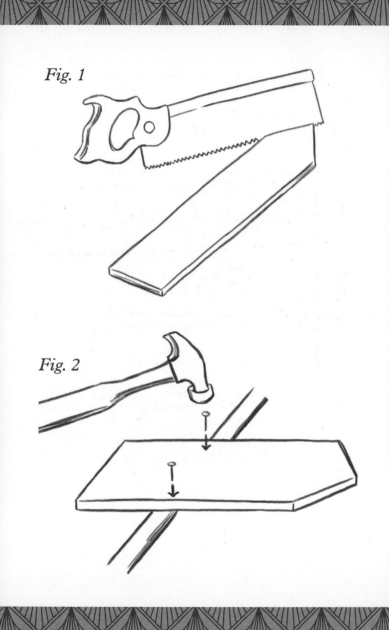

Fig. 1

Fig. 2

TO MAKE THE SIGNPOSTS:

1. Cut the planks, so they have one straight end and one pointed – some to the left and others to the right. You can use as many as will fit on your pole (see Fig. 1).

2. Decide whether to keep your signs rustic, or if you'd prefer to paint them white/a colour of your choice; if the latter, paint them now, with as many coats as you need so they're opaque. Allow to dry completely between coats.

3. Choose your fictional locations. You can either write these freehand on the planks (first in pencil) or find some free stencils online (try freeprintablestencils.com). You could also vary fonts or keep them uniform. Paint the letters in colours of your choice, allowing them to dry completely before moving on to the next stage.

4. Hammer the planks into place on your pole, allowing two nails per plank (one at the top and one at the bottom – see Fig. 2). You can arrange the order and directions as you see fit.

Position your signpost in its designated spot and get ready to explore the literary world.

HAMLETTER

To B, or not to B? Or maybe C? These might just have been the answer to Hamlet's existential angst – if only he'd had a scroll saw. A nice touch for weddings or just to sit prettily on a shelf, they also make great gifts for anyone who has initials.

YOU WILL NEED:

- Pencil
- Hardback book with a lovely cover
- Scroll saw/jigsaw or similar

Fig. 1

Fig. 2

TO MAKE THE LETTER:

1. Draw or trace the shape of your letter on to your book cover. You can either do this by hand or by printing a single letter to the size you need, cutting it out and drawing around it. You may need to adjust your letter slightly to ensure enough of it sits along the spine. So for an A, you can keep it flatter up the sides before sloping in (see Fig. 1); or for a J, you can flip the book over and draw it on the back.

2. Use a saw to cut along the outline of the letter (see Fig. 2). A scroll saw is going to be the easiest thing to use, but with enough will and dexterity a jigsaw or similar could work.

It really is that easy. And the rest is silence.

THE DECOUPAGE
OF INNOCENCE

Forget the scandal that might follow the departure of an unwanted husband – the real humiliation in today's world is an unsightly mug ring in full view atop your writing desk. But with this fashionable craft you'd be right at home in the Gilded Age – just make sure you have a tea set to match.

YOU WILL NEED:

- A base (you can choose pretty much anything you fancy – a tile, a wood slice, a jam-jar lid, a cork square or similar)
- White paint
- Book pages (thicker paper is better)
- Mod Podge
- Sealer (resin or VHT Engine Enamel)

Fig. 1

Fig. 2

TO MAKE THE COASTER:

1. Unless your chosen surface is already white, it would be best to spread white paint over it first, so you have a blank base. Apply as many coats as necessary, until it is all white, allowing the paint to dry in between coats.

2. Choose the part of your book pages you want to use, whether pictures or interesting bits of text. Use the coaster base to trace around by cutting out the same shape from the paper (see Fig. 1).

3. Dampen the paper slightly with water – this will help to reduce wrinkles.

4. Apply a coat of Mod Podge to the top of the coaster and place your paper shape on to it, smoothing out any air bubbles very carefully (you don't want to rip the paper; see Fig. 2). Wipe away any Mod Podge that has squeezed out the sides.

5. Leave for at least 15 minutes to dry, then add another coat of Mod Podge.

6. Once this has dried, add the sealer (following the instructions of the product you are using).

And there you are – beautiful coasters to adorn any coffee table (and, hopefully, convince visitors of your superior social status).

THE JUNGLE BOOKMARK

Losing your place in a good book is like getting lost in a jungle, with no clue how to find your wolf pack or the man village. If such a prospect strikes dread into your heart, this next craft should provide you with the same sort of solace as a black panther by your side, guiding you to safety.

YOU WILL NEED:

- Old hardback books with pretty spines
- Scissors/craft knife
- Coloured/patterned card
- Craft glue
- Ribbon (satin might work best)

Fig. 1

Fig. 2

TO MAKE THE BOOKMARK:

1. Cut the spines from your books with a knife or scissors, as carefully and as straight as possible.
2. Cut a piece of card to the same size and shape as the spine.
3. Brush the back of the spine with a thick layer of glue (about the width of the ribbon).
4. Lay the ribbon lengthways down the centre of the spine, leaving several centimetres sticking out the end (see Fig. 1).
5. Spread some glue over the card, and stick it on to the spine, with the ribbon sandwiched in between (see Fig. 2). Press down hard and clean off any excess glue.
6. Place the bookmark under something heavy overnight to flatten it.

Phew! You're safe now. You'll never lose your place again.

NOT THE PICTURE OF DORIAN GRAY

No need to hide this craft up in the attic! Display it proudly on a mantelpiece for all to see. Just make sure you choose a book that adequately demonstrates your youth and vitality – because it will be captured there for ever.

YOU WILL NEED:

- Scissors
- Sheet of paper
- Hardback book
- Metal edge ruler
- Pencil
- Sharp craft knife
- Photo (slightly smaller than your book)
- Masking tape

Fig. 1

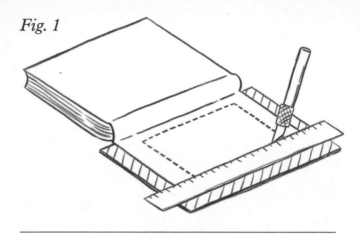

TIP: *It would be best to place something under the cover in step 3, so you don't cut too deep – preferably a cutting mat, but a piece of cardboard would work.*

Fig. 2

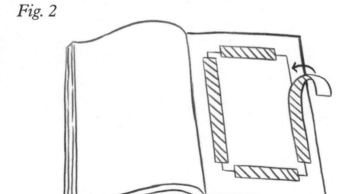

TO MAKE THE BOOK FRAME:

1. Cut a rectangle out of the sheet of paper, a little smaller than your photo – say, 12mm off the length and width.

2. Decide which way up you want to display your photo and turn the book that way. Place the paper in the middle of the cover, using a ruler to make sure it's centred, then trace around it with a pencil.

3. Use a craft knife and metal ruler to cut out the rectangle from the book cover, placing the ruler along the lines you have traced to ensure you are cutting in straight lines. You should expect to pass over each line at least five times before you cut through, so don't try to force your way (see Fig. 1).

4. Open the book and place your photo behind the opening, ensuring that it's the right way up.

5. Use masking tape to secure your photo in place, sticking around all four sides (see Fig. 2).

The picture (not Dorian's, but likely your friends/family/pets) is there for ever now. (Or at least until you decide to swap it out for something new.)

BOW COUNTRY
FOR OLD MEN

Sometimes a man can get so deep into trouble – a drug deal gone wrong, a stolen satchel containing $2.4m – that he can't see a way out of it. He knows he'll be pursued relentlessly, until either he or those tracking him are dead. Oh, how he wishes he could draw a line under what's happened, tie a great big bow around the problem and leave it behind. Fortunately, with this gorgeous – and very easy – paper bow craft, he may be able to do just that!

YOU WILL NEED:

- Book page
- Scissors
- Glue gun/strong glue

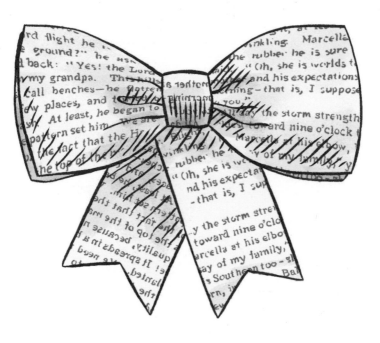

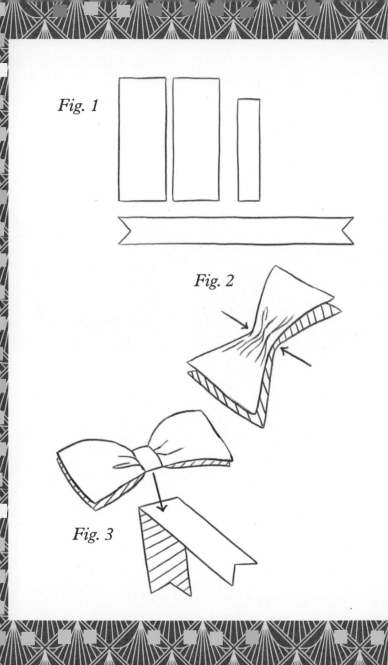

Fig. 1

Fig. 2

Fig. 3

TO MAKE THE BOW:

1. Crumple up the book page, then uncrumple it. This will make it more malleable.
2. Cut four shapes out of the paper: two should be 10 x 4cm; one should be 8 x 2cm; and the last should be 18 x 3cm. On the last one, cut little triangles from each end to create the bow tips (see Fig. 1).
3. Put the two 10 x 4cm bits of paper together, one on top of the other, and scrunch in the middle so they are bow-tie shaped (see Fig. 2).
4. Wrap the 8 x 2cm strip around the middle, then glue it at the back.
5. Bend the last piece in half, at an angle, so the ends fan out from one another. Glue this piece at the back of the bow (see Fig. 3).
6. Fluff the sides of the bow.

These bows are great for sticking on presents, cards or envelopes. Or they can be strung together to make cutesy literary bunting.

AESOP'S TABLES

This table ain't no fable! With just some old books, some wood and some glue, you can make a real bedside table to warm your heart upon waking in the morning or turning in at night.

YOU WILL NEED:

- Books of various sizes (around 25 in all)
- Mod Podge
- Strong glue (Liquid Nails, E6000 or similar)
- Piece of plywood (44.5 x 51cm)
- Paintbrush

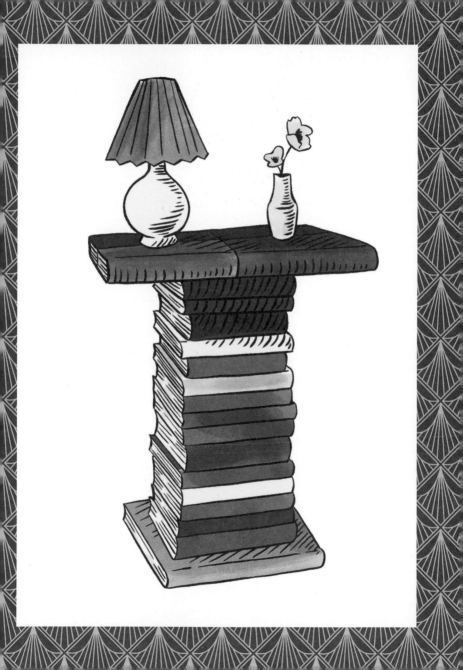

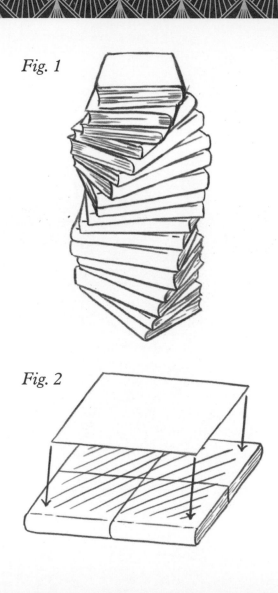

Fig. 1

Fig. 2

TO MAKE THE BEDSIDE TABLE:

1. You will need to stick the pages of each of your books together, so they essentially become building bricks. To do this, firstly use Mod Podge to glue the insides of the covers to the first and last pages. Then (with each book closed), spread Mod Podge around the sides where the edges of the pages are visible.

2. Decide how you want to stack the books you have glued – whether to vary sizes throughout or go from the largest on the bottom to smallest on top. Also, decide if they will all be flush or whether you will arrange them in a spiral (see Fig. 1).

3. Then, use the strong glue to stick the books together, starting from the bottom and working your way up (reserving four books of roughly the same size and thickness for the tabletop). Remember that until the glue dries the books might slide, so keep an eye on them. You may also want to place a couple of bricks/something heavy on top to weigh them down.

4. Take the piece of plywood and glue the bottoms of the four books you kept aside to it. The books should be bigger than the plywood, so make sure they stick out the same amount on all sides (see Fig. 2). Weigh these down while they dry, too.

5. Once the glue has dried on the plywood tabletop and the book stand, add glue to the top of the latter and centre your plywood on top of it (book side facing up). Weigh it down and wait for it to dry.

And the moral of this craft? Everything is better when it's made of books.

THE HUNDRED AND ONE CARNATIONS

Crafters, beware: these eternal blooms are so beautiful that you may need to guard them from deranged flower-mad villains, intent on making clothes out of your handiwork. Fortunately, they're so simple and so affordable, you could make yourself a whole carnation plantation to replace any that are lost to hired thieves.

YOU WILL NEED:

- Scissors
- Handful of book pages
- Glue
- 25cm length of wire (craft or florist's wire)

Fig. 1

Fig. 2

TO MAKE THE FLOWERS:

1. Cut narrow strips from the book pages, about 1cm wide.

2. Apply a thin layer of glue along one side of the strips, then wind them around the wire to cover its entire length.

3. To make the centre of your flower, cut a strip of paper that is 4cm wide and the full length of your paper. Apply glue along the bottom edge and stick one end to the top of your wire stalk. Wind the rest around the stalk, starting with tight circles and gradually loosening. The bottom edge of the strip will naturally slip a little down the stalk as you continue to wind (see Fig. 1).

4. Draw and cut out petal shapes in varying sizes (roughly the size of Fig. 2). Start with a few, and then make more as required.

5. Starting with the smaller ones, and one by one, dab glue along the bottom of the petals and stick them on to the 'stem', lining up the base of the petals with the bottom edge of the centre you've just made. Curl them around the centre slightly, to make a more natural shape.

6. Continue adding petals, turning the stem as you go and increasing the size of the petals the further out they are.

These make for the perfect everlasting bouquet for a book lover (just don't put them in water) and ideal decoration for weddings. Why not make a whole bunch?

HIDDEN TREASURE ISLAND

Ahoy there, buccaneers! Whether ye have uncovered some buried gold or simply have some nice heirloom earrings ye don't want to lose, every good pirate knows the importance of concealment. And with this secret cavity in an old book, there's no need for deserted tropical islands and spades – you can hide your favourite treasure in plain sight, and no one will ever find it! (Unless they have a hankering to read that particular book, of course.)

YOU WILL NEED:

- Thick hardback book
- Cling film
- Mod Podge
- Wide paintbrush
- Pencil
- Ruler (preferably metal)
- Craft knife

TRESURE ISLAND

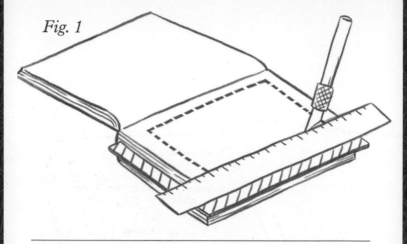

Fig. 1

TIP: *To ensure you stop cutting at the right point in step 4, slip a cutting mat or some cardboard underneath the last page you want to cut.*

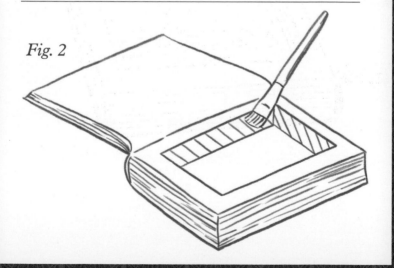

Fig. 2

TO MAKE THE TREASURE ISLAND:

1. Open your chosen book and turn over the first few pages. These will not be cut, ensuring that even if someone else does open the book, the secret cavity inside will remain hidden. Stick cling film over these first pages and the front cover to prevent any glue from getting on them, then close the book.

2. Use a paintbrush to spread Mod Podge across the exposed edges of the pages to hold them together and stick the final page of the book to the back cover. Place something heavy on top of the book, then leave to dry.

3. Open the book to the top page that you're going to cut and use a pencil and ruler to draw a border on the page, 1cm around the edge.

4. Cut along the lines you've drawn, using the ruler to make sure they are as straight as possible (see Fig. 1). You should expect to only cut through a few pages at a time, so don't worry about pushing too hard. Stop when you have a few pages left – it's best to finish with a visually appealing page at the bottom, such as a chapter opener or illustration.

5. Brush Mod Podge on to the inside cut edges, to keep the sides of your box in place (see Fig. 2), then spread another layer on to the outside edges of the book, too. Leave to dry.

Now all you need to do is to fill the hidden space with treasure and mark the location of your loot to prevent you from losing it. (You really don't want to have to search through every book you own, trying to find the one you cut the middle out of several years before.)

HOWARD'S BOOK END

'Only connect' these books to some metal bookends and your books will appear to stand up upright on their own! And just as the ancient, noble wych elm of Howard's End embodies the mystical spirit of the place, so too shall these seemingly invisible bookends enthral and delight your visitors.

YOU WILL NEED (FOR 2 BOOKENDS):

- 2 hardback books
- Mod Podge
- Glue brush
- Two thin, basic metal bookends (shorter and thinner than your book)
- Hot glue gun/superglue (Gorilla or similar)

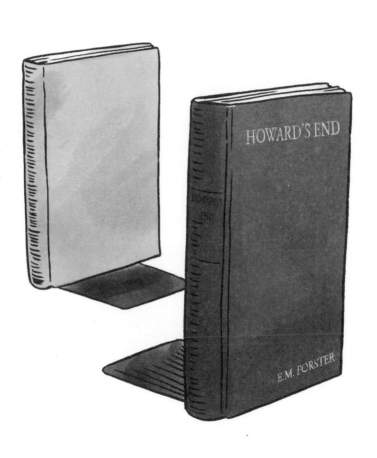

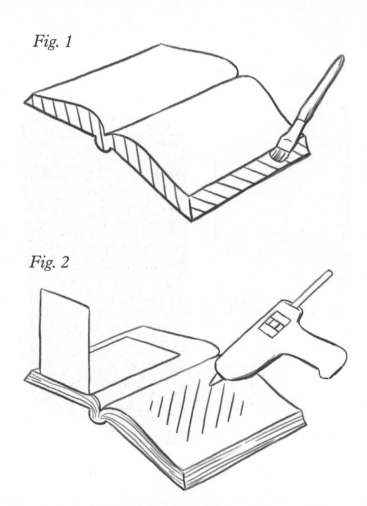

Fig. 1

Fig. 2

TO MAKE THE BOOK ENDS:

1. On each of your books, use Mod Podge to glue the insides of the covers to the first and last pages.
2. Open each book up in the centre. Spread Mod Podge along the edges of the pages of each book, on both parts, so they are all stuck together (see Fig. 1).
3. Place a piece of paper in between the two parts, turn the books on their backs and put something heavy on top to weigh them down. Wait for the glue to dry, then spread another layer on the edges.
4. When dry, remove the piece of paper and place the metal bookends inside each of the books, so the longer part is concealed inside and the shorter part sticks out at the bottom. They should be arranged so that when both spines are facing you, the bottom part of the bookends go in different directions (towards each other).
5. Use the hot glue gun/ superglue to stick the book end in, putting glue on both sides of it and the rest of the page (see Fig. 2). Weigh it down while it dries.

All men are equal – all men, that is, who possess invisible bookends.

THE GRAPES OF WREATH

If you make this beautiful book-page wreath, you will certainly have many sour grapes and jealous Joads in your neighbourhood! Much more interesting than your standard holly and ivy, this eye-catching piece will show off your skills as much as your literary creds.

YOU WILL NEED:

- Large metal wreath hoop (any size)
- Wire cutters/pliers
- Book pages (lots of them)
- Stapler
- Hole punch
- Hot glue gun/superglue

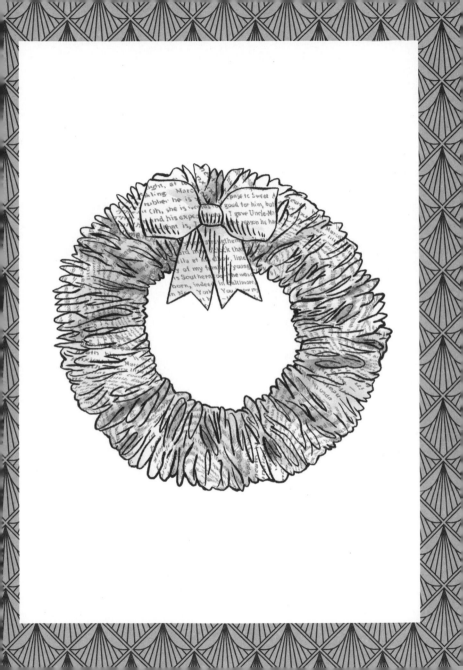

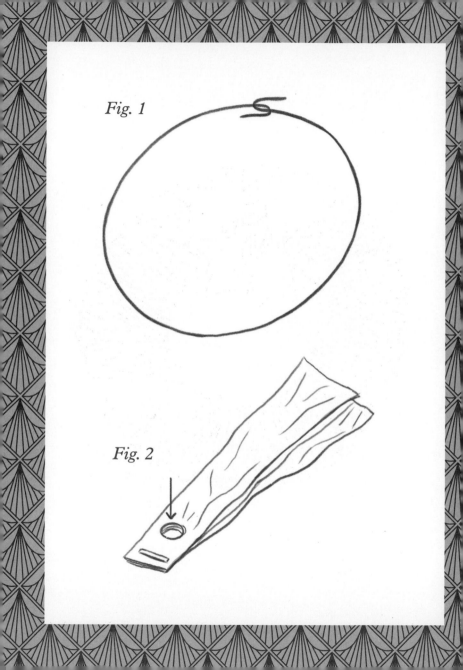

Fig. 1

Fig. 2

TO MAKE THE WREATH:

1. If you're lucky enough to have found a hoop with a clasp, great! If not, clip your wire hoop and use your pliers/cutters to curl the ends, so that they can clasp shut (see Fig. 1).

2. Take your book pages and cut them in half, lengthways. Scrunch them up, straighten them, and then fold them twice, along their length. Staple each piece at the bottom, then punch a hole just above where you've stapled (see Fig. 2).

3. Thread the pages on to the hoop, slipping them on through the punched holes. You should stagger them slightly, placing them at different angles, and use your glue gun/superglue to stick them to the ring. Add a little glue between the pages, too, so they'll remain stuck to each other. Keep going, until your hoop is well packed with pages.

4. To make this even more festive, why not add the bow from page 66?

Let your wreath take pride of place – just make sure it's not somewhere it's going to get damp, or you'll be feeling some wrath of your own.

GAME OF CONES

A wedding is coming. So simply grab some pages from your favourite romantic novel (or one about people destroying each other in their race to the throne), order in some biodegradable confetti and get crafting. But do watch out for the wine at the wedding – it may not contain poison, but it could still make one of your cousins think it's ok to jump naked into the water fountain.

YOU WILL NEED:

FOR THE CONFETTI CONES:

- Glue stick
- Single book pages (one per cone)
- Biodegradable confetti

FOR THE CONE PRESENTATION TRAY (HOLDS 12):

- Glue
- Lid of an A4 printer paper box
- More book pages
- Ruler
- Pencil
- Craft knife/scissors

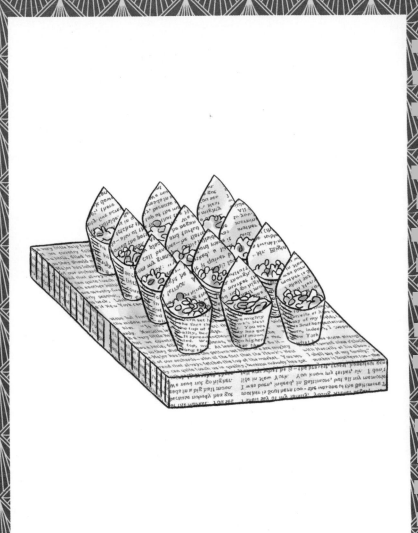

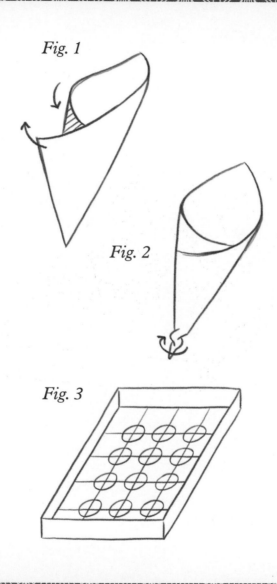

Fig. 1

Fig. 2

Fig. 3

TO MAKE THE CONES:

1. Take two opposite corners and roll the paper into a cone shape, closed at the bottom and open at the top (see Fig. 1). Twist the bottom point over a couple of times (see Fig. 2), then glue down the outer flap (hold it for a couple of seconds to ensure it is stuck).

2. Repeat to make as many cones as you need!

TO MAKE THE BOX:

1. Stick the book pages so that they cover the outside of the box lid (top and sides), positioning them at different angles and overlapping for a nice, rustic feel, while ensuring the entire thing is covered. If the lid is coloured/has writing on it, you may need several layers.

2. Turn the lid over and use a ruler to measure lines out on the inside. Divide the long side into five sections (a line every 6cm) and the shorter side into four sections (a line every 5cm). You will be placing a cone at the intersections, so draw a circle (around 2cm in diameter – see Fig. 3) at each of these twelve points.

3. Cut the circles out with a craft knife or scissors.

4. Once they're all cut, simply place a cone into each of the holes and fill with confetti.

And if someone asks you why you've destroyed books for the sake of your wedding décor? Tell them they know nothing. Or that a lion doesn't concern itself with the opinions of sheep. Works every time.

CHITTY CHITTY HANG HANG

Oh, you, pretty Chitty Hang Hang, Chitty Chitty Hang Hang, we love you! This lovely craft is a real crowd pleaser for visitors to your home – and you can make as many as you have coats. It's surprisingly easy and quick, so you don't need to be anywhere near as scared of it as you should be of that childcatcher.

YOU WILL NEED:

- Scrap piece of wood – not too thick and cut smaller than the book
- Old book
- 6 long screws (for length, see method)
- Mod Podge
- Coat hook and screws
- Screwdriver
- Stiff paintbrush
- Two D-ring hangers and screws

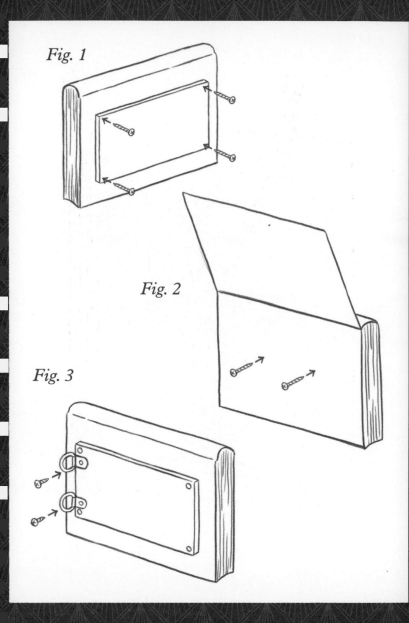

Fig. 1

Fig. 2

Fig. 3

TO MAKE THE HOOK:

1. Position the piece of wood in the centre of the book's back cover and screw it in place with a long screw in each corner – they should be long enough to go through the board and most of the way through the book (see Fig. 1).

2. Flip the book over and open the front cover. Put two more screws in through the first page to help keep the book together (see Fig. 2).

3. Apply Mod Podge all over the inside of the front cover, as well as on the edges of the book pages, ensuring you push the glue into all the crevices. Put something heavy on top of the book to weigh it down and leave it to dry.

4. Attach the two D-ring hangers to the board at the back, as per their instructions, ensuring they are exactly level with each other (see Fig. 3).

5. Attach your hook to the front of the book, as per the pack instructions.

Now you just need to choose the perfect place to hang it – and hammer in some nails to hang it on. (Why not sing 'Chitty Chitty Bang Bang' as you hammer? What a happy time you'll spend!)

NINETEEN
EIGHTY-DOORMAT

*Whether or not you live in a true totalitarian society,
have appeared on the Channel 4 show of the same name,
want to make a statement about how governments are
watching us through our phones and tracking our every
movement or simply have an overprotective older sibling,
this Big Brother craft is for you! Of course, you could
choose another slogan that may not freak your guests out
as much – but where's the fun in that?*

YOU WILL NEED:

- Plain coir doormat
- Printable stencil in font of your choice
- Freezer paper and iron/adhesive vinyl
- Computer and printer
- Cricut/craft knife
- Stiff paintbrush
- Flex Seal or outdoor paint in colour of your choice
- Sealant, such as Flex Seal spray

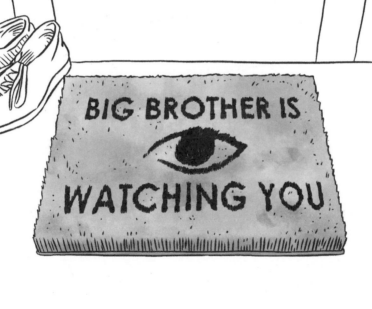

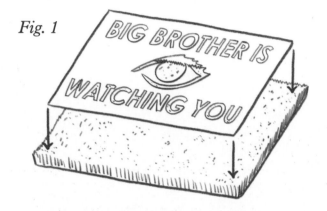

Fig. 1

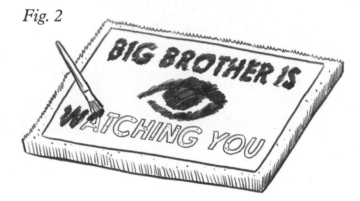

Fig. 2

TO MAKE THE DOORMAT:

1. Choose the writing you want to appear on your doormat and sketch out how you want the letters arranged – the dimensions will depend on the size of your doormat and the number of letters in the phrase you choose.

2. Once you know the dimensions of each of your letters, you can size them on your printable stencils accordingly (Google will throw up a number in all sorts of fonts). Using Word or a similar application, fit as many letters as you can on each page to eliminate waste when you print them.

3. Cut the freezer paper/vinyl to the size of an A4 page (29.7 x 21cm), place it in the printer drawer and print on to the matt side. Cut out using a Cricut, if you have one, or a craft knife. Scissors also work but will be more fiddly!

4. Position the stencil on the doormat, ensuring it all lines up perfectly. If you're using freezer paper you should iron this on, or peel off the backing paper if using vinyl (see Fig. 1).

5. Use a stiff paintbrush to dab paint to form the letters, taking care to push it straight down around the edges to keep them neat. Make sure this is a thick coat, so none of the original doormat colour shows through. This may require another layer or touch-ups (see Fig. 2).

6. Once dry, remove the stencil and apply a sealant to seal the design. Leave for at least a day before using.

You could always make your own stencil for the Big Brother eye to go beneath the words, or even employ a 'Newspeak only' policy within your household, for added authenticity.

MOBY TICK

There are some crafts that you wait your whole life to land. Those that are so monumental and look so great in your house that they become the stuff of legend. Fortunately, unlike taking revenge on a humungous white whale, this craft is actually super easy and won't take too long! The result will also look far better on your mantelpiece. (And you won't be contributing to climate change – have you seen that Seaspiracy documentary!?)

YOU WILL NEED:

- Old hardback book
- Clock-making kit
- Pencil
- X-ACTO/craft knife
- Scrap wood
- Drill and bits
- Clock numbers (optional)
- Superglue (optional)

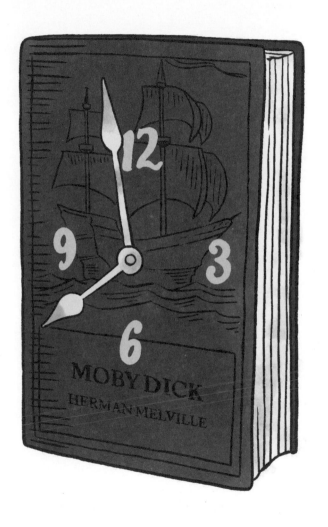

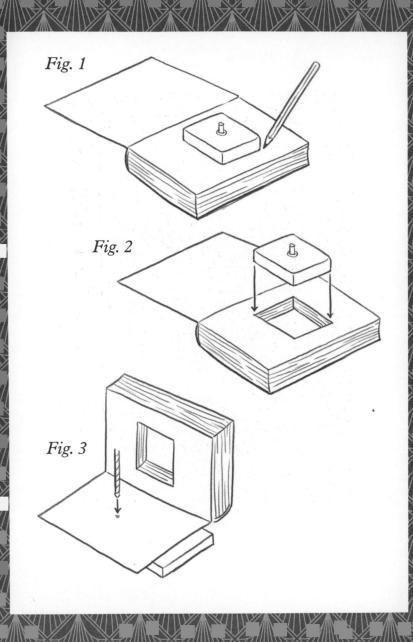

Fig. 1

Fig. 2

Fig. 3

TO MAKE THE CLOCK:

1. Decide on where you want the hands to be placed on the book, which will likely be dependent on the book design (whether centred or to the side, higher or lower).

2. Open the book at the very start, place the clock mechanism at the right point (dependent on step 1), and draw a line around it with a pencil (see Fig. 1). This is where it will be embedded in the book.

3. Use a knife to cut into the book along these lines, deep enough that the main part of the mechanism will sit flush with the cover. You should expect to cut only a few pages at a time, so don't press too hard (see Fig. 2).

4. Place the mechanism into the hole, rub pencil on to the shaft, then close the book on top of it and press down. This should leave a slight mark on the front cover, showing you where to drill.

5. Open the book again and manoeuvre it so that the front cover is face down on your scrap wood. Either ask an assistant to hold the book in place or find something to prop it up against. Select a drill bit the same size as the mechanism's shaft and drill a hole through the front cover, into the wood (see Fig. 3).

6. Put the rubber washer from the clock-making kit on to the shaft, and push it through the hole from behind, securing the other side with the metal nut from the kit screwed on to it.

7. Follow the instructions on the kit for adding the hands to the clock.

8. Another option is to supergluc clock numbers to the book, but you may wish to go with a cleaner look and not have any.

Now your clock just needs a battery and to be set to the correct time, and you should be ticking!

THE SECRET GARLAND

You most definitely shouldn't keep this garland a secret, but you may find making it as transformative and life-affirming a process as Mary Lennox experienced in returning an old forgotten garden to its former glory. As the garland blossoms to life in your hands, staple by staple, allow yourself to connect to the simple pleasure of creating something beautiful, of giving an old book new life. Beauty is where we find it, and true happiness can be found in making something lovely in our small corner of the world.

This garland can be as long or short as you choose, which is why the instructions may appear a little vague. (To create one long enough for a standard mantelpiece, you may need an entire book.)

YOU WILL NEED:

- Book pages (many)
- Black coffee (optional)
- Sponge (optional)
- Stapler with lots of staples

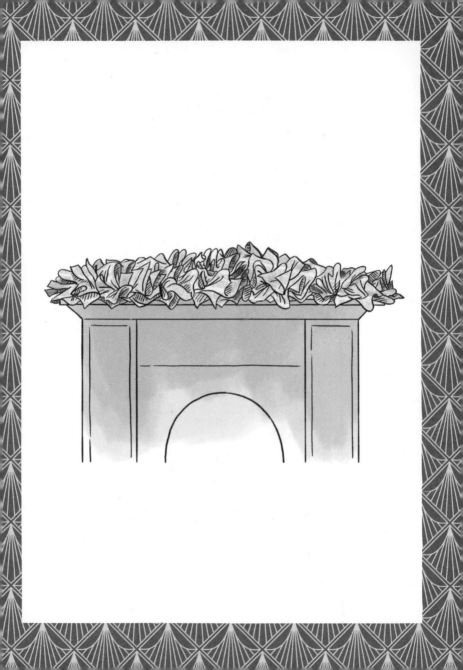

Fig. 1

Fig. 2

TO MAKE THE GARLAND:

1. An optional step would be to coffee stain your paper before you get started, to give the craft more of an antique feel. To do this, take a bit of leftover coffee and wet the pages, using a sponge. Then either leave/hang the pages to dry or heat them in the oven on a low heat (this will only take a few minutes, but you should do just a few pages at a time).

2. Take the pages, one at a time, and loosely fold them into a fan shape (without pressing along the folds), stapling at the base of each fan (see Fig. 1). Some fans should be tighter and some looser – the lack of uniformity adds to the finished effect.

3. Once you have done a few, start stapling them together, joining the bases in a line (see Fig. 2). This will take a lot of staples to secure but, don't worry – no one will see them. Just be very careful not to accidentally staple your finger.

4. Keep going until you are happy with the length (or you run out of book pages), then display in your place of choice (taking care to position so the staples are out of sight).

This garland is fantastic for the festive season, but suitable for any time of year. After all, if you look at it the right way, you can see that the whole world is a garland.

THE BUNTING
OF THE SNARK

So lovely a thing to adorn your room,
Or hang in a wedding marquee,
Spell the names of the bride and the groom,
For all your guests to see.
But beware, my friend, of a spelling mistake,
In the name of your beloved.
For you may not be given a piece of the cake,
Or your whole life be allowed to forget it.

YOU WILL NEED:

- Dictionary with letters centred on the page
- Scanner and printer/photocopier
- Card
- Ruler and pencil
- Scissors
- Length of ribbon

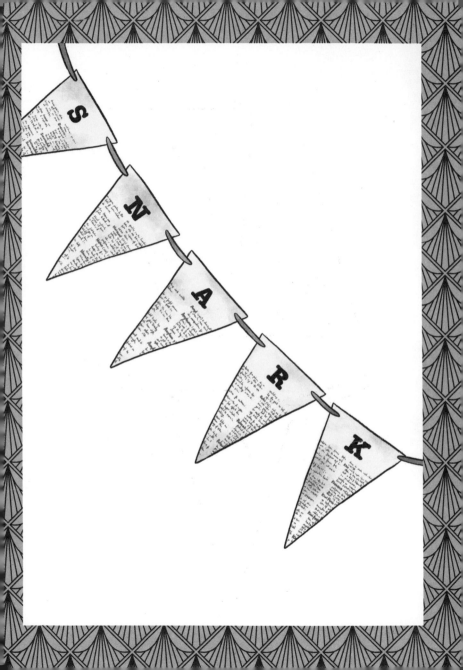

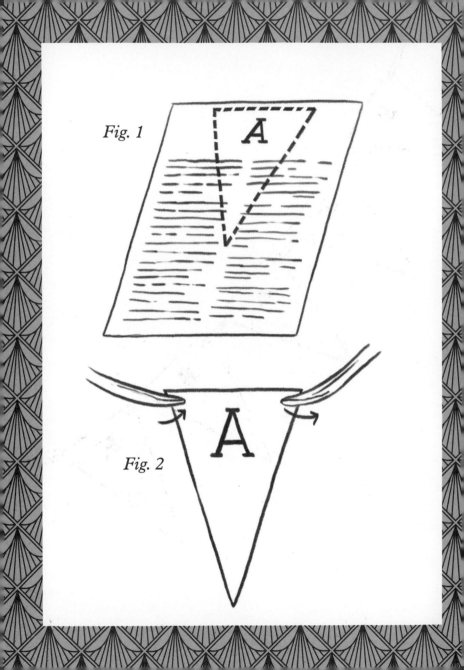

Fig. 1

Fig. 2

TO MAKE THE BUNTING:

1. First, you need to decide what you want your bunting to say. And unless you have countless dictionaries to cut up, the best thing would be to scan copies of the relevant book pages and print them out on to card, ensuring you have all the letters you'll need. Alternatively, it is possible to find scans online.

2. Use a ruler and pencil to measure out triangular bunting shapes on each of the pages, all the same size, with the letter centred at the top (see Fig. 1). The size you make them will depend on how big you want the bunting to be and how many letters you're trying to fit on. Cut these out. If doing multiple words on the same bit of ribbon, you could make a blank triangle on your card to go between the words, to make them easier to read.

3. On each triangle, make an incision on either side at the top, ensuring they are level with one another.

4. Starting with the first letter in your word, pass the ribbon through each of the holes (see Fig. 2). Continue with each subsequent letter, until your word/words are complete.

5. Ensure you have enough ribbon on either side to hang it.

This is lovely, this is lovely, this is lovely. What I tell you three times is true.

LADY CHATTERLEY'S KINDLE COVER

All ladies have secrets. And whether that secret is a passionate affair with a sexy gardener or that she likes reading on a Kindle, despite purporting to only buy print, she has the right to guard her private business – and fiercely so. Fortunately, with this nifty craft you can do just that. Whatever you're reading, it will look like you're engrossed in a classic literary hardback! And for those of you who still want the feel of a book in your hands, while your eyes prefer the enlarged fonts enabled by digital, this is a perfect marriage of both worlds.

YOU WILL NEED:

- Craft knife
- Hardback book (approximately 2.5cm wider and taller than the device you wish to encase, and not too much thicker)
- Coloured/patterned paper
- Adhesive Velcro tape

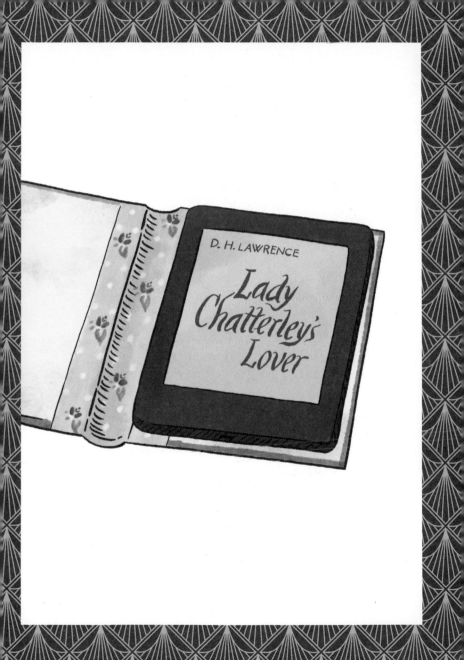

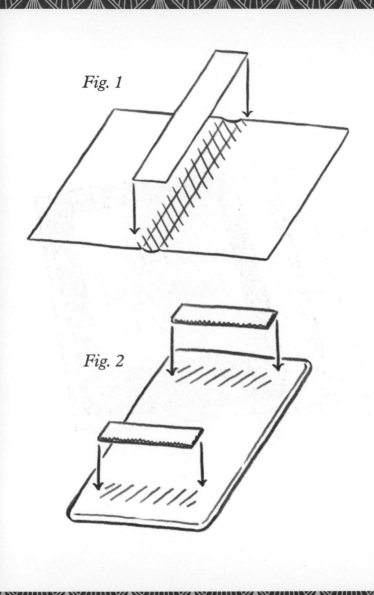

Fig. 1

Fig. 2

TO MAKE THE KINDLE COVER:

1. Use a craft knife to carefully cut away the book pages to leave only the covers. (Keep the pages for one of the other excellent crafts in this book.)

2. Lay the cover down with the inside facing upwards. Measure the width and length of the spine. Then, adding 1.5cm to the width, cut out a piece of the paper to these measurements. Glue it down to the spine with equal amounts of paper overlapping on either side. Smooth the paper out so there are no creases (see Fig. 1).

3. Apply two strips of adhesive Velcro to the back of your Kindle – placing one along the top and one along the bottom (see Fig. 2). Attach the opposite sides of the Velcro to their mates, then remove the backing and press them against the inside back cover, making sure they are centred and straight. This will ensure both sides of the Velcro are lined up before sticking, to hold your device in place.

Read away! Whether your jam is true crime, memoir, YA or the exploits of Constance and Mellors, you simply cannot judge a book by its e-reader cover.

SCARY POPPINS

Toys that tidy themselves away? A woman flying in on the East Wind? Being sent shooting up to the ceiling to drink tea with a man who can't stop laughing? With all these spooky occurrences every which way you look, Scary Mary Poppins is surely the ultimate Halloween read! And the best way to honour this terrifying, practically perfect nanny? Transform an old book into a beautiful Halloween pumpkin decoration. You may not scare any bookworms away, but this pumpkin will strike fear into the heart of any disobedient children who dare darken your doorstep.

YOU WILL NEED:

- Craft knife
- Old paperback book
- Pencil
- Hot glue gun
- Orange spray paint
- Small stick
- Natural raffia ribbon

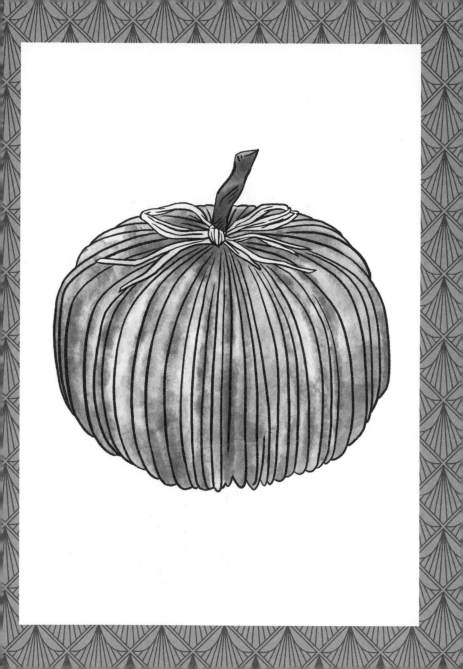

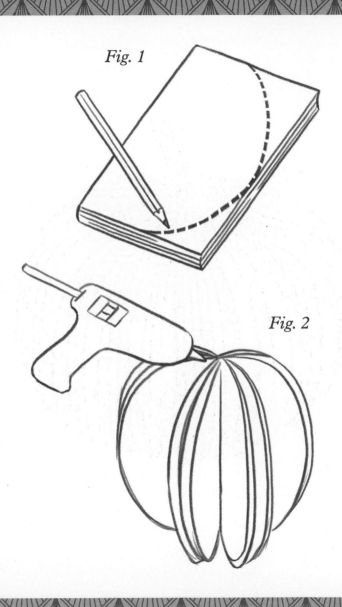

Fig. 1

Fig. 2

TO MAKE THE PUMPKIN:

1. Use a craft knife to remove the book cover. Set it aside for one of the other crafts in this book.

2. Draw a semi-circle with a pencil on the top-most page, with the spine of the book block as the long straight edge (see Fig 1). It doesn't need to be perfect.

3. Use the craft knife to cut into the lines you've drawn, cutting a few pages at a time until you have cut it out of the entire block. Again, perfection is not the goal; some rough edges will add to the effect at the end.

4. Bend the spine of the book back to make it pliable and start fanning the pages out. Use a hot glue gun to apply glue to the spine and first and last pages. Carefully bring those pages together and hold them until they've stuck. Fan out the pages to make your pumpkin nice and full.

5. Spray paint the book pumpkin, preferably outdoors, making sure you have even coverage.

6. Use the hot glue gun to attach the stick to the top of your pumpkin, nestling it into the gap in the spine.

7. Tie some natural raffia ribbon to the base of the stick to finish the look off.

Keep it out until the wind changes... Or 1 November.

TIP: *It may be time-consuming, but for best results put a spot of glue between each of the pages in the gutter, to help keep them separated (see Fig 2).*

ALICE THROUGH THE BOOKING GLASS

Have you ever wanted to step into a book? To leave your troubles behind, entering a fantastical world, where nursery-rhyme characters are real and logic is reversed? Where up is down and down is up, parties are work events and lies are truth?

Just as Alice stepped through a mirror to find a land of wonder, so too can this craft make a mirror your entry point into the crafting elite.

YOU WILL NEED:

- Old book
- A4 paper
- Mod Podge
- Glue brush
- Grosgrain ribbon, around 1cm wide and 30cm long
- Mirror (size of your choice, but smaller than your book)
- Ruler
- Pencil

- Cutting mat (or piece of cardboard)
- Craft knife
- 2 x 75mm mending plates
- Awl
- Screws, shorter than half the thickness of the book
- Screwdriver

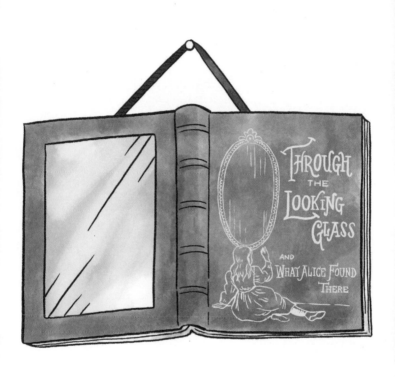

Fig. 1

TO MAKE THE MIRROR:

1. Open the book to the very centre and slip the piece of paper in to keep the place. Starting with the first half, divide it into two again and open on that page. Brush Mod Podge over both pages, and place one end of the ribbon about 7cm down from the top edge, centred (see Fig. 1). Close the book to stick the ribbon in place. Then find the same point midway in the back half and repeat with the other end of the ribbon. Close the book, weigh it down with something heavy and leave it to dry.

2. Turn the book over so the back cover is facing you. Place the mirror so that it is centred on the back cover (use a ruler to check) and draw around it with a pencil. Sliding a cutting mat or piece of cardboard between the back cover and the last page, cut along these lines and remove that section of the cover (see Fig. 2). Glue the insides of both covers and close the book, pressing down to stick them to the first and last pages, Repeat and weigh it down to dry.

Fig. 2

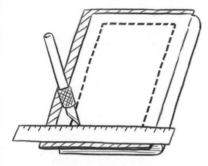

3. Glue the back of the mirror and place it in the space in the back cover, pressing it into place. Leave to dry.

4. Open the book to the centre point again, really cracking the spine, so it lies as flat as possible, and brush glue all around the outer edges of the book pages on either side. Ensure that you press glue into the crevice between cover and paper to really make sure they stick. Place the piece of paper back in between the two halves and close it. Weigh it down with something heavy and wait for the glue to dry. Repeat with another layer on the edges.

5. To help keep the book open and flat when it is hanging, add the mending plates. To do this, open the book again with the inside facing up. Centre the mending plates over the spine, one at the top and one at the bottom of the book. Make a small hole through the plate holes with an awl, then place the screws through these and secure with a screwdriver (see Fig. 3).

Fig. 3

When everything is dry you can hang it in your place of choice, using the ribbon. You may just find yourself getting lost in Wonderland every time you glance at your own reflection.

WAR AND CENTREPIECE

While it may not be the sort of table decoration that would have been found at Anna Pavlovna's salon soirée, this arrangement will make you quite the talk of society. But let me tell you, producing it is certainly no epic tale (and won't take nearly as long as reading a 587,287-word novel). In fact, it's so simple, it almost doesn't count as a craft; yet the result is so breathtaking, it is worth taking seriously. The combination of book-page runner and artfully arranged stack of books makes a perfect table centrepiece for literary-themed weddings, book clubs, baby showers or simply a dinner you want to be extra special.

YOU WILL NEED:

FOR THE TABLE RUNNER:

- Book pages
- Transparent packing tape

FOR THE CENTREPIECE:

- Several beautiful books
- Ribbon or twine (optional)
- Scrabble tiles and tray (optional)
- Flowers, candles (optional)

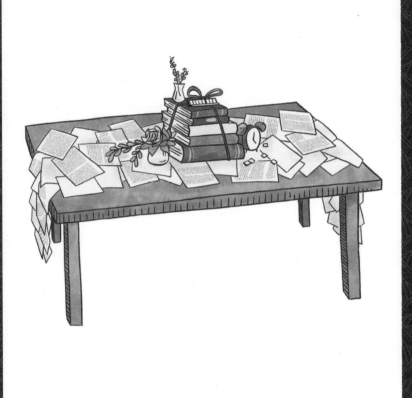

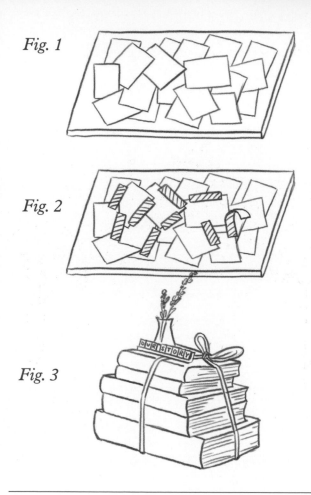

Fig. 1

Fig. 2

Fig. 3

TIP: *For a long table, you may wish to have the table runner dropping over the edges, in which case, simply complete step 1, as above, then shift the pages along the table and add more.*

TO MAKE THE TABLE RUNNER:

1. On the table you're planning to decorate, lay out all the pages at random, ensuring they overlap with no gaps (see Fig. 1).
2. Use the packing tape to stick all the pages together. Don't be stingy with the tape, as you don't want any pages to become unstuck. This side won't be on show, so don't worry about the appearance (see Fig. 2).
3. Flip the runner over. If any of the pages seem to be loose, add a loop of tape underneath them and press down.

TO MAKE THE CENTREPIECE:

1. Create a stack of the most beautiful books you own, either straight or at different angles.
2. Add any embellishments – say, tying them up with ribbon or twine. You can be as creative as you wish; I have seen them placed in decorative birdcages before. Particularly eye-catching elements would be a Scrabble tray and tiles, perhaps spelling out 'OUR STORY' (for a wedding), the name of a book that you're discussing for book club, the name of your guest of honour (particularly if you're throwing them a dinner party) or anything else that feels appropriate.
3. Finish off with a little vase of flowers and you'll have a table fit for Russian royalty (see Fig. 3).

And you are ready to dine! Anyone in the mood for some kvass and kasha?

THE PICNIC PAPERS

Come, Snodgrass! Come, Winkle! Come, Pickwick! Let us go to the hills, lunches in hand, for a picnic in England's green and pleasant land. Joe will likely fall asleep, and we can't trust Job Trotter not to siphon off some of the wine – but oh, with just a picnic blanket and these perfect literary sandwich bags, we're sure to make it a day to remember!

YOU WILL NEED:

- A4 piece of book paper (either found in this size, or scanned and resized)
- Glue stick

TO MAKE THE PICNIC BAG:

1. Turn the book page horizontally, and loosely fold both sides over so that they overlap in the middle by a couple of centimetres. Press down along each of the sides and glue the two edges together (see Fig. 1).

2. Fold each of the sides over towards the middle, so that the flaps are around 2.5cm wide and the space between them is the same (see Fig. 2). Press to make crease marks down each side, and then open the flaps back out again.

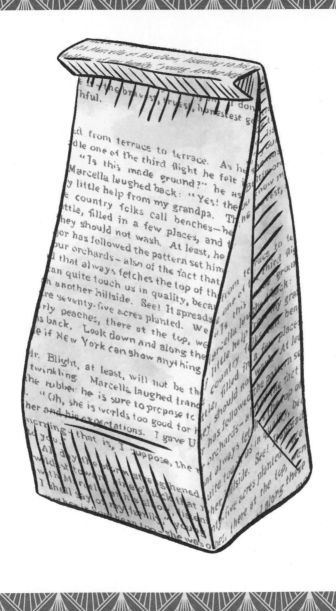

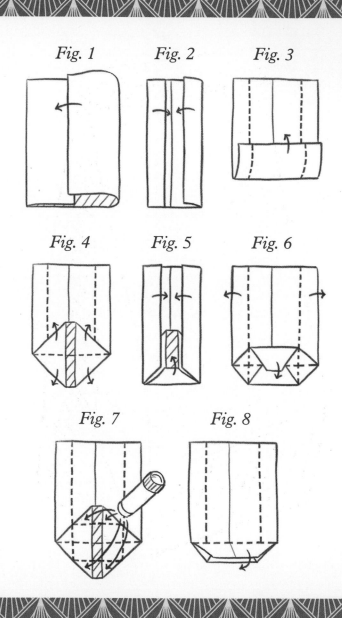

Fig. 1 *Fig. 2* *Fig. 3*

Fig. 4 *Fig. 5* *Fig. 6*

Fig. 7 *Fig. 8*

3. Fold the bottom edge upwards, not quite to the centre – the flap should be around 6cm long (see Fig. 3). Crease this line and then fold back.

4. This next step can be a little fiddly: taking the bottom edge, open up the hole, pushing the two corners together, until they lie flat along the bottom line of the paper in a diamond shape, but with a flat edge at the top and bottom (see Fig. 4).

5. Fold the sides in again along the creases you made in step 2 and re-crease them all the way down. Then take the bottom of the diamond shape and fold it upwards so that it fits neatly in the space beneath the two side flaps (see Fig. 5).

6. Open the two sides out, keeping the bottom of the diamond folded up. Then take the top of the diamond and fold it down to overlap with the bottom (see Fig. 6).

7. Apply glue on all the points shown in Fig. 7. Stick the bottom part of the diamond down first by folding upwards. Then fold the top part down and press down to stick.

8. Take the top edge of what will now be a 6-sided shape and fold it downwards over the bottom half (see Fig. 8).

9. Place your hand into the hole at the top and open it out from the inside, pressing into the bottom corners. On each of the long sides, push the creases inwards so that the bag will stand on its own.

Once filled – brandy or pineapple rum optional – you can simply roll the top over a couple of times or secure with a suitable sticker.

SHELFTH NIGHT

If shelving be the food of love, DIY on! This craft is perfect for shipwreck survivors and homemakers alike, whether you're using driftwood from the seashore or you've just paid a visit to your local hardware shop. Why not use this unique shelf to display some of your favourite volumes (see page 72 for some invisible bookends), a photo frame (see page 52) or decorative book letters (see page 40)?

Just like Viola, you'll be leaving people guessing – is it a shelf. . . or three books somehow defying gravity?

YOU WILL NEED:

- Wood paint in colour of your choice
- Wooden shelf brackets
- 3 old books of the same thickness and width
- Plank of wood (roughly 10cm wide, 2cm thick and about 10cm shorter than the length of all three books laid out lengthways)
- Pencil
- Ruler
- Cutting mat (or piece of cardboard)
- Craft knife
- Mod Podge
- Glue brush
- Liquid Nails (or any high-strength adhesive)

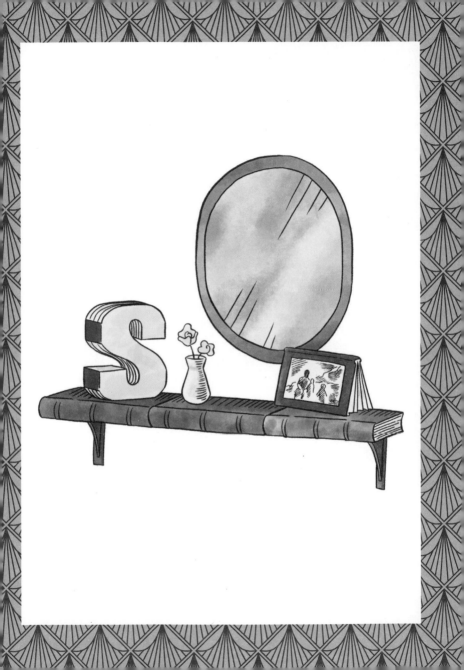

TO MAKE THE SHELF:

1. Paint the shelf brackets and set them aside to dry.
2. Lay your books out end to end with the spines facing the same way and the covers facing upwards. Open the books about thirty pages in and weigh down the first section of each book to keep it open, as these pages won't be cut.
3. Lay the piece of wood across the other sections of the books and draw around it with a pencil. This is where you will be cutting into them, with the aim that the wood will sit in the middle, unseen.
4. Measure the exact depth of the piece of wood. This is the depth you will need to cut into your books, so measure the same depth on the books and slip a cutting mat or piece of cardboard under the last page you need to cut. Cut out the pages in each of the books – you shouldn't expect to cut too many pages at a time, so don't try to press too hard (as in Fig. 1).
5. Brush the wood with Mod Podge on all sides, except the long edge that will be on the outside. Drop the wood into the space you've made

Fig. 1

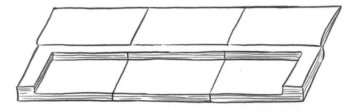

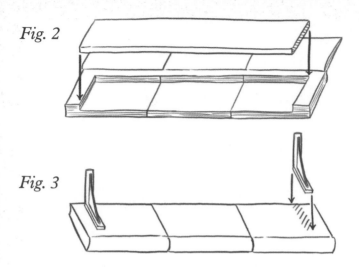

Fig. 2

Fig. 3

(see Fig. 2). Brush Mod Podge all over inside of the front and back covers, then close the books and brush more of it into the edges of the book pages, taking care to get into all the crevices. Put something heavy on top of the books to weigh them down and leave them to dry.

6. Turn the shelf so that the front covers are facing downwards. Measure out where you will apply the brackets – one at each end, equidistant from the edge. Apply Liquid Nails to the top of the brackets and press them into the shelf at the points you have measured, making sure they are flush (see Fig. 3). Hold for about a minute, then leave to dry overnight.

7. Attach to the wall as per the instructions for the brackets.

Some are born great, some achieve greatness and some only get there when they make a shelf out of books.

ABOUT THE AUTHOR

Virginia Wool was an English writer, feminist and craft-obsessive. The seventh child in her family, she spent most of her youth searching for the perfect place to house her burgeoning craft collection. She described creating seminal works of modernist fiction as a frivolous pastime – an amusing distraction from her more serious pursuits: like making a 2-metre-tall papier-mâché lighthouse. *A Loom of One's Own*, her most famous piece of non-fiction, centres around her search for creative freedom and her very own loom, featuring all her favourite literary-inspired crafts.